CLICK!

FUN WITH PHOTOGRAPHY

W9-CKJ-369

Susanna Price & Tim Stephens

Sterling Publishing Co., Inc. New York

Photography by: Susanna Price
Editor: Ann Kay
Designer: Helen James

Talbot Fox illustrations
and dinosaur model: Guy Callaby
Other illustrations (23, 33, 37): Helen James

The publishers would like to thank the following
for their invaluable help with this book:
Archway Pool, north London; British Waterways; the Joyce, MacDonald, Marriot-
Dixson, Pick and Schaffer families; Hackney City Farm, north London; Mosquito Bikes
(UK) Ltd, London; Nikon UK Ltd, London; Techno Retail Ltd, Euston Road, London;
the staff, pupils and parents at William Tyndale School, north London.

Library of Congress Cataloging-in-Publication Data

Price, Susanna.
 Click! fun with photography / Susanna Price & Tim Stephens.
 p. cm.
 Includes index.
 Originally published:london:Belitha Press
 Summary: Presents the basics of photography, from choosing a
camera to making the most of the flash.
 ISBN 0-8069-9541-6
 1. Photography—Juvenile literature. 2. Cameras—Juvenile
literature. [1. Photography. 2. Cameras.] I. Stephens, Tim. II. Title.
TR149.P75 1997
771—dc21 96–37211
 CIP
 AC

Published by Sterling Publishing Company, Inc.
387 Park Avenue South, New York, N.Y. 10016
First published in Great Britain in 1995 and
copyright © in this format by Belitha Press Limited 1995
Photographs copyright © Susanna Price 1995
Text copyright © Tim Stephens 1995
Illustrations © Belitha Press 1995
Distributed in Canada by Sterling Publishing
c/o Canadian Manda Group, One Atlantic Avenue, Suite 105
Toronto, Ontario, Canada M6K 3E7

ISBN 0-8069-9541-6 Trade
 0-8069-9652-8 Paper

Words in **bold** appear in the glossary on page 44.

Reprinted by arrangement with Sterling Publishing Company, Inc.
Printed in the USA.
10 9 8 7 6 5 4 3 2 1

Contents

Foreword

Taking photographs can be great fun. You can capture particular moments in time, such as occasions with your family or friends and places that you have visited, recording things that have amazed or amused you.

The word "photography" means drawing with light, and today's simple modern cameras have made it easy to get the technical details right. But good photography relies on the person choosing the subject, taking the photograph from the right angle and distance, framing the subject and, above all, deciding on the strength and direction of the available light.

You can improve your results by thinking carefully about the photographs you take. Use your camera for projects based around a theme. Try to understand how what you see will appear in the final photograph. Practice a lot—and be critical. The more pictures you take, the better they will be.

John Hedgecoe

CHECKLIST

✔ From time to time, you will see a checklist that looks like this.

✔ The checklist sums up the main points made in the text near the checklist.

✔ When you have finished the book, you can use the checklists as handy reminders of some of the basic principles.

Introduction

Everyone can take great photographs with the huge range of light, easy-to-use cameras around today. We see photos wherever we go, in magazines and newspapers and in advertisements in the street. But most of the photos taken today are shots of family, friends, school and vacations snapped by ordinary people.

These photos can be just as powerful and exciting as a professional photographer's, and they are great fun to take. You don't need lots of equipment, just plenty of enthusiasm and ideas and a basic camera. *Click! Fun with Photography* takes you a step at a time through the basics of photography, from choosing a camera to making the most of your flash. There are also plenty of ideas for projects which will make the most of your skills and equipment.

The book concentrates on taking photos with a fairly simple compact camera. There is also extra information on how to use a more complex compact or a single lens reflex (SLR) camera.

Most of the information on SLRs is in the Talbot's Tips boxes. These are introduced by Talbot Fox (below), who is named after one of the early pioneers of photography—Fox Talbot, an Englishman who lived in the 1800s. Talbot Fox explains more complex techniques.

CLICK START

All kinds of good cameras are available in a huge variety of prices. Choices range from disposable cameras that are thrown away when the film is processed, to easy-to-use compacts, to more complex models called single lens reflex (SLR) cameras.

CHOOSING A CAMERA

When choosing a camera, you need to think about which type will suit you best, as well as how much money you have to spend.

● Disposable cameras are very simple, fixed-focus cameras which you simply point and shoot. They work well if there is enough light.

● Compact cameras guarantee good photos in most conditions because their controls adjust automatically.

● Advanced compact cameras have manual controls, which you can alter yourself.

● **Single lens reflex cameras** give you even more control over the photos you take.

● There are also cameras designed for special conditions, such as taking photos underwater.

▲ DISPOSABLE

These **automatic** cameras look like large boxes of **film**. The film is built into the camera case. When you have finished your film, you send the camera to a film processor, who pulls the case apart to develop the film. The camera can't be used again.

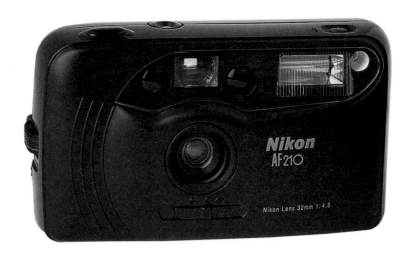

▲ BASIC COMPACT

Simple compact cameras have a **viewfinder** which has markers that help you frame your picture. They have a **lens** that can cope with most ordinary conditions. They also have automatic focus, **exposure** and a **flash** (which can often be turned off). Many compacts automatically detect the speed of the film you put in them.

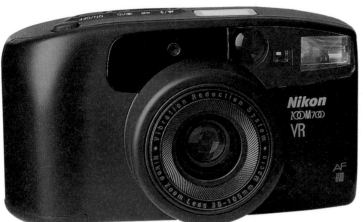

◀ ADVANCED COMPACT

Advanced compact cameras often load, wind and rewind film automatically. They may have a lens which lets you zoom in close or take wide-angle shots. Many have a display panel that tells you what is happening, and some models can even cut down on **camera shake**.

▶ SPECIAL CAMERAS

There are also cameras that can do special things. This model is a waterproof underwater camera. Because you can't make many adjustments underwater, it has automatic focus and exposure and a built-in flash.

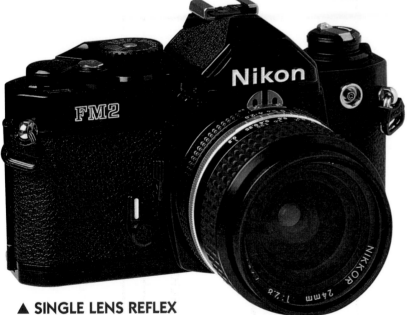

▲ SINGLE LENS REFLEX

When you use an SLR camera, the image you see through the viewfinder is exactly what the lens sees. The two are not quite the same on a compact camera, which can cause problems with close-ups. Many SLRs have both manual and automatic controls. When you want to use a flash, you need to fix a **flash unit** to the top of the camera.

CHECKLIST

✓ Choose the right camera for the photos you want to take.

✓ Disposable cameras are ideal for taking simple photos in good light.

✓ Compacts are fine for taking photos in most conditions.

✓ In difficult conditions, you may need an SLR camera.

HOW A CAMERA WORKS

Basically, every camera works the same way. The main features that you find on all modern cameras are marked on the compact camera below. The numbered key explains how they work. A few other common features are also shown.

● When you take a photograph, light travels through the lens of the camera and on to the film inside.

● The diagram on the right shows how the image forms upside down on the film because of the way light rays enter the lens.

● If film is exposed to too much light, it becomes **fogged** (clouded). To prevent this, a camera has a **shutter** like a door.

● When you press the button on your camera, the shutter opens, letting in light.

FRONT VIEW

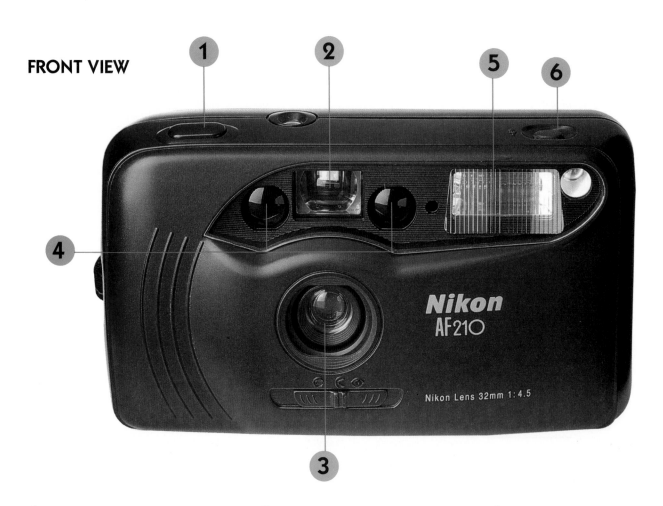

Nikon AF 210

Nikon Lens 32mm 1 : 4.5

1 Shutter release button
This opens the shutter to let in light. The amount of light depends on how long the shutter stays open—the shutter speed. It also depends on the size of a hole inside the camera called the **aperture**. The shutter speed and the aperture control the amount of light that strikes the film. This is known as the exposure. Both can be changed manually or automatically.

2 Viewfinder
Looking through this window shows you roughly what will appear in your photograph.

3 Lens
Camera lenses are made of glass or plastic. They bend light rays to form an image on the film. Moving the lens closer to or farther from the film focuses the image (makes it look sharp).

4 Autofocus window
A light beam comes out of the autofocus window and measures how far the subject is from the camera.

5 Flash unit
This gives an extra flash of light when light levels are low.

6 Flash on button
Turns on the flash.

TAKING A PHOTO

This diagram shows how a camera lens focuses on the subject and forms an image on the film inside the camera.

● Light rays reflected from the subject pass through the lens.

● The shutter lets these rays through. The rays then pass the aperture (shutter and aperture are the same thing on some cameras).

● Passing through the curved lens makes the rays bend and cross. Because they cross, the image formed on the film is upside down.

● How much the light bends controls the **focusing**.

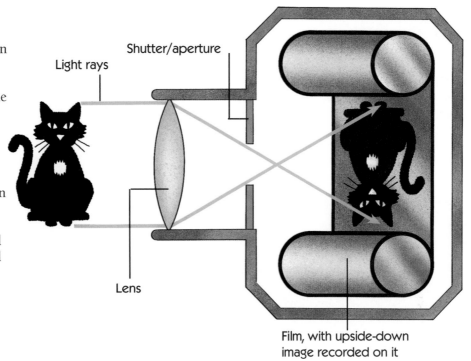

Shutter/aperture

Light rays

Lens

Film, with upside-down image recorded on it

BACK VIEW

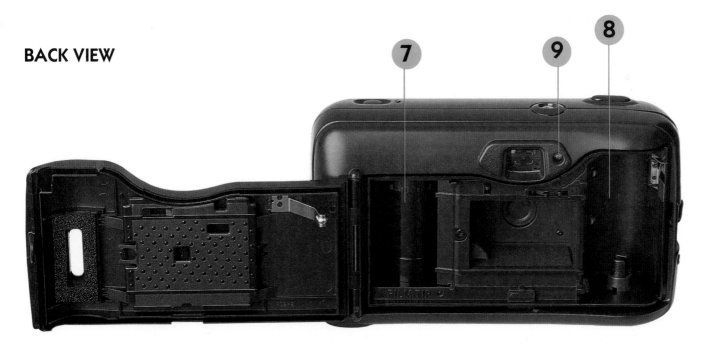

7 **Film take-up spool**
As you use up the film, it is wound around this spool.

8 **Film chamber**
This is where you put the film cassette when you load the camera.

9 **Flash ready light**
This light tells you when the flash is ready for use.

TALBOT'S TIPS

Here is some more information about lenses on SLR cameras or compacts with manual controls.

● You can buy a range of lenses for all SLRs, and some compacts have a built-in adjustable **zoom lens**. Different lenses have different **focal lengths**. The focal length is the light-bending power of a lens. A short focal length means that you will get a wider angle of view. Focal length is measured in millimeters, and the focal length of a standard SLR lens is about 50mm.

● The shorter the lens, the greater the **depth of field**. The depth of field is the area in front of and behind your subject that is also in focus.

◀ This zoom lens is like several different lenses in one. You can adjust its focal length to give a range of views from wide angle to close-up. At the right-hand end of the lens are markings called **f-stops**. Changing the f-stop alters the size of the aperture.

▶ This photo was taken with a **macro lens**. These lenses are designed for close-up work because most **standard lenses** don't focus well on subjects which are closer than 3 feet (1 meter).

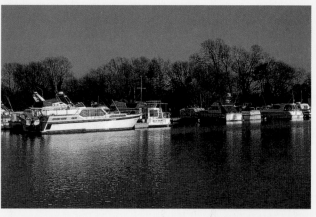

◀ Standard lenses give a reasonably wide view and fairly large depth of field—although our eyes can see a much wider view than this.

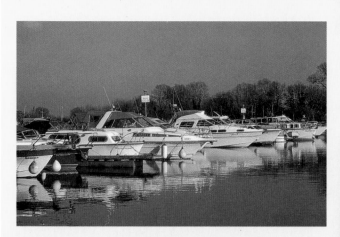

▶ A **wide-angle lens** fits a much wider view into the picture. These lenses range from 18mm to 35mm. An 18mm lens is called a **fish-eye lens**. It fits so much in that the image curves inward at the edges.

CHOOSING FILM

All photographic film is coated with a substance that is sensitive to light.

● When the film is exposed to light, an image forms on the film. The film is then removed from the camera and processed. **Prints** or **slides** are produced from this processed film.

● The three main types of film are shown below. Different **film speeds** are given **ASA** (American Standards Association) or **ISO** (International Standards Organization) numbers.

● For poor lighting conditions and fast-moving subjects, use a fast film such as ASA 400.

● In bright light or when using a flash, work with slower films such as ASA 100 or 200.

Most film comes in cassettes like this.

BLACK AND WHITE FILM

In the early days of photography, only black and white film was available. Most people now use color film. Black and white prints are quite expensive, but you can achieve stunning results with them.

This pattern—the **DX code**—tells some kinds of camera the speed of the film.

COLOR SLIDE FILM

This gives a **positive image** (right) when processed, and is made into slides. The other two films on this page produce **negative** images (where light areas are dark and dark areas are light), from which prints are made.

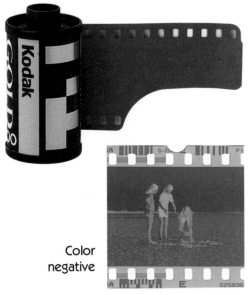

Color negative

COLOR PRINT FILM

Color print film is the most popular type. When the film is processed, you get a negative (see left), and prints are produced from this. All color films are made from three light-sensitive layers sandwiched together. Between them, these layers record all the different colors in the **light spectrum**.

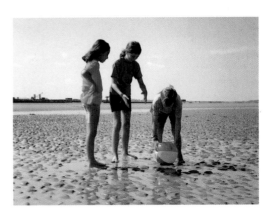

LOADING FILM

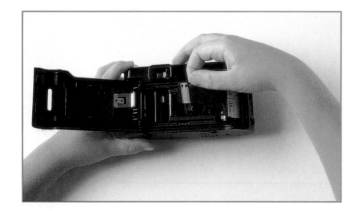

1 Place the camera face down on a flat, clean surface, away from bright light. Open the back and put the film in the compartment on the right. Carefully pull the edge of the film (the leader) to the left.

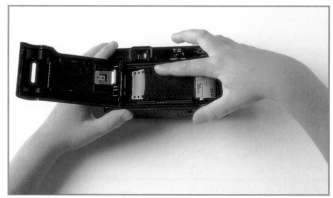

2 Fit the film over the teeth (if there are any) on the take-up spool. Make sure to pull out only enough film to line up with the position marked on your camera.

3 Make sure the film is lying flat between the film guides. Then close the back of the camera firmly.

4 On many compacts, if you press the shutter release button halfway down, the film automatically winds until it's ready to take the first picture. The film counter will show the number 1.

TALBOT'S TIPS

● Some compacts and all SLRs need to be loaded by hand. On SLRs, pull out just enough film to reach the take-up spool. Put the film leader into the slot in the spool (if there is a slot). Then, using the wind-on lever and pressing the shutter button in turns, wind the film onto the spool until you've used up all the leader. Close the camera back.

● On some cameras, the film compartment is on the left and the spool on the right. Follow the instruction booklet for your camera.

CHECKLIST

✓ Check the light. The film will cloud up if you load it in bright light.

✓ Make sure the film lies flat and is lined up with the guides.

Make sure the holes in the film fit over the teeth on the spool

✓ Be sure to close the camera back securely.

UNLOADING FILM

1 When you've used up the film, either the counter won't advance or you won't be able to press the button down. On this model, you wind the film back into its cassette by sliding the rewind switch in a certain direction.

2 When you have rewound the film completely, open the back of the camera and take it out. On basic compacts and older SLRs, you have to press in a button on the bottom of the camera and rewind the film into the cassette by hand.

3 More advanced compacts rewind automatically. On many models, you can rewind the film before you've used all of it, so that you can change to another type of film. Be sure to leave out a little of the film leader, so that you can reload the film.

HOLDING YOUR CAMERA

● One of the main problems in taking photos is camera shake, which blurs the pictures. To avoid it, hold your camera like the girl on the right.

● To help prevent camera shake, many cameras automatically select fast shutter speeds. If you're using a non-automatic camera, choose an exposure of $1/60$ of a second—or faster—to keep your picture shake-free.

● As you saw on page 8, the windows on the front of a compact camera have vital jobs to do, so be sure not to cover them with your fingers. Most important, don't cover up the lens. Remember, you can't tell whether you're covering up the lens by looking through the viewfinder. The view isn't the same as it would be if you were looking through the lens, which is the case with an SLR.

To keep the camera level and still, hold it with both hands.

Make sure your fingers, hair and the camera strap aren't in front of the lens or the flash.

Keeping your elbows tucked into your sides helps to steady the camera.

Stand with your legs slightly apart so that you feel balanced and comfortable.

First Steps

Now you can start taking all kinds of exciting pictures. Compact cameras take a lot of the effort out of photography and give great results. But it's still easy to make some basic mistakes. If you learn how to avoid them, you'll get much better results right from the start. There is one popular subject you can always have fun with—your friends.

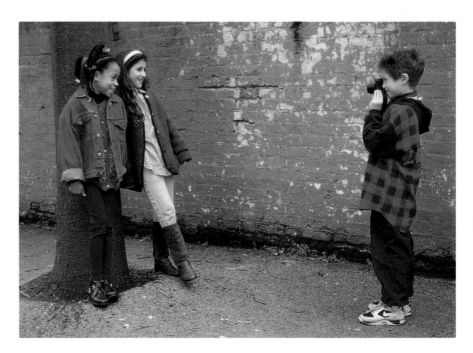

FOCUSING

When you look at a scene, you focus on a subject that is the center of attention—even if it's not in the center of your field of view (the area you can see in front of you).

Cameras don't know what they're supposed to be looking at—you need to focus them. You can do this either manually (**free focus**) or automatically (**autofocus**).

You can free-focus all SLR cameras, using the same lens that takes the pictures, so you can be sure which part of the picture is sharp.

Most autofocus cameras focus on the center of a scene. They use **infrared light** to measure how far it is to the center, and then a motor adjusts the lens. But you can fool an autofocus camera (see caption at the right). Many cameras now have a preview option which does this.

◀ Most autofocus cameras have a focus marker (shown here in yellow) in the middle of the viewfinder. Position this over your subject before you shoot. The boy here isn't quite in the center, so he is fuzzy while the wall is sharp.

◀ You can get a much sharper picture when you "fool" the autofocus camera. Point it at the area you want in focus. Press the button halfway down to set off the focus mechanism. Then move the camera to where your subject is and press the button all the way down.

COMPOSITION

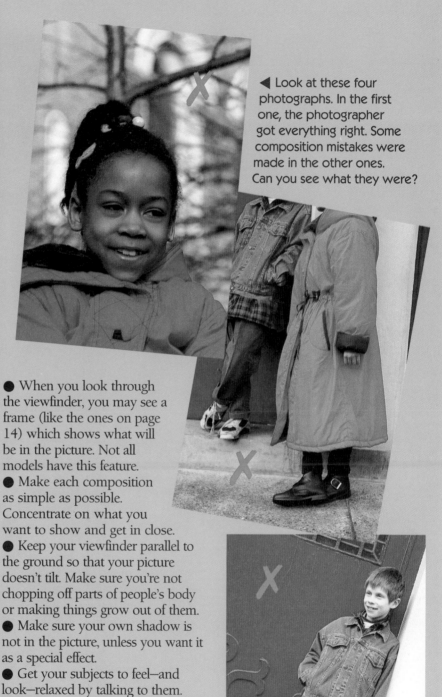

◀ Look at these four photographs. In the first one, the photographer got everything right. Some composition mistakes were made in the other ones. Can you see what they were?

Composition is all about how you select your subjects and **frame** them (arrange them in the picture area). Good composition creates pictures that convey all sorts of feelings and messages.

● When you look through the viewfinder, you may see a frame (like the ones on page 14) which shows what will be in the picture. Not all models have this feature.

● Make each composition as simple as possible. Concentrate on what you want to show and get in close.

● Keep your viewfinder parallel to the ground so that your picture doesn't tilt. Make sure you're not chopping off parts of people's body or making things grow out of them.

● Make sure your own shadow is not in the picture, unless you want it as a special effect.

● Get your subjects to feel—and look—relaxed by talking to them.

● It may be worth having a quick rehearsal. Even professionals practice before they use up film.

☐ CHECKLIST ☐

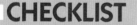

✔ Be careful what you concentrate on.

Make sure that nothing looks as if
✔ it's growing out of anyone's head.

✔ Keep the picture level.

✔ Watch out for your own shadow.

✔ Try to relax your subject.

✔ Get as close as possible to your subject.

LANDSCAPE OR PORTRAIT?

Some animals that live in wide-open spaces have excellent landscape (horizontal) vision, so that they can scan for movement of other animals. We see in a more circular way, so we can enjoy both **landscape** and **portrait** (vertical) **formats**. By simply turning your camera sideways, you can take portrait-type pictures, which often work better than a landscape shape.

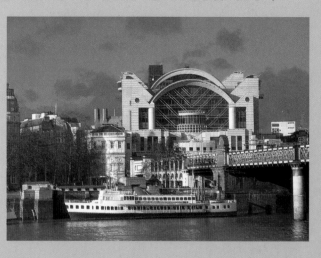

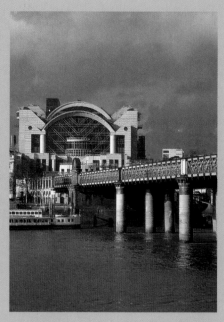

▲ This landscape picture draws attention to the ship and to the architecture behind. The bridge draws the eye into the center of the picture.

▲ This portrait view forms a strong design because it's off center with lots of sky and water.

SIMPLE SELF-PORTRAITS

1 Find a place that you can get to quickly once you've set up the camera. Choose somewhere with a flat surface to rest your camera on. Avoid standing at a spot where you'll be looking into the sun because this will make you squint.

3 When you're happy with the composition, think about the exposure. Switch on the flash if it's a dull day and you want the group to stand out against the background.

Turn on the time exposure switch. Press the shutter button halfway down to pre-focus. Then press the button down all the way and run around to get into the picture.

If you want to appear in your own photos, you're going to be taking **self-portraits**. This is a good way to learn how to pose for pictures, because you are in total control. It's easy to take self-portraits if your camera has a **self-timer**. Or you can attach a **cable release**, if you have one. This is a long cable that has a remote button.

2 Place your camera securely on the flat surface and carefully compose your photo. If you are taking a picture of a group of people, remember to leave space for yourself in the composition.

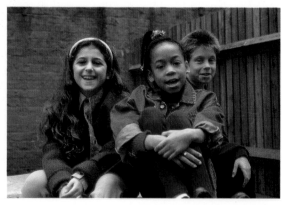

16

EXPOSURE

Getting the exposure right used to be one of the main problems for photographers. Using the correct exposure makes a photo come alive. Combining the right exposure with good composition and subject matter will give you great results.

● A photo is correctly exposed when the amount of light that reaches the film accurately records all the details of the subject. The picture should capture the full range of tones in your subject, from light to dark.

● Exposure is a combination of shutter speed and lens aperture (opening). Compacts normally set this combination automatically, so you have little control. But on SLRs, you can set a slow speed with a small aperture and get the same result as a fast speed and a wide aperture. As long as the right amount of light reaches the film, it doesn't matter which combination you use.

▶ The photo of the boy is overexposed. Too much light got through, so the only detail you can see is in the shadows. ▼ The picture of the girls is underexposed, so we can't see anything at all in the shadows.

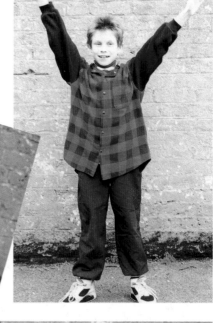

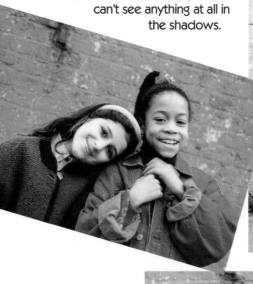

▶ Correct exposure, as in this photo, gives you lots of detail in every part of your picture, capturing a full range of tones, from the shadows to the lightest highlights.

Gift tags

It's a good idea to save all your photographs, even those that didn't come out as you'd hoped. Making gift tags is just one of the ways you can use spare prints.

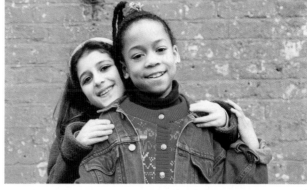

Use pictures of yourself—or of something about the present you're giving—or of the person receiving the present. You can also add extra details to your tags with a felt pen.

1 Cut out your tags with a pair of scissors.

2 Fix a tie to your tags. Either tape a short length of cord to the back of them, or make a hole in the tag with a hole punch and thread the cord through.

17

Moving on

Now that you know something about cameras, film, composition, focusing and exposure, you can begin to experiment. Take pictures of your friends and family in different natural lighting conditions and in all kinds of situations—from bicycling in the park to shopping at the mall.

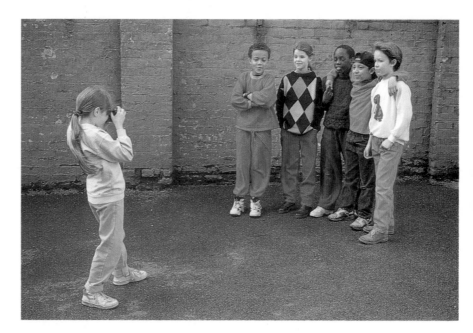

GROUP PICTURES

Here are a few pointers for good group shots.

● Arrange the group quickly—people lose patience fast, and you don't want a photo of bored people.
● Arrange people by height. This looks natural and keeps taller people from blocking shorter ones.
● Make sure that strong shadows don't fall on part of your group. Watch for this when the light comes from the side.
● Group pictures can create a particular mood. Ask people to stand or sit in positions that express the mood you want.

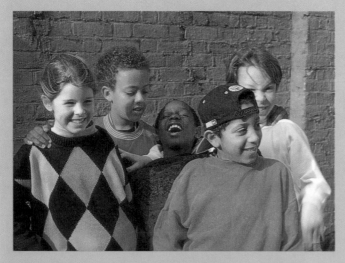

▲ This is a successful shot showing a happy, relaxed group. But the photographer made a couple of mistakes. One friend is in strong shadow, while another has half his face hidden from view.

▶ You might think this picture is a disaster— perhaps the photographer pressed the button at the wrong time. But hands, legs and feet make interesting shapes that produce unusual, dramatic shots.

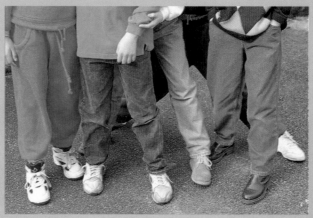

LIGHTING

Light is one of the most important parts of photography. When you start taking photos, concentrate on making sure you have enough light. As you gain experience, you can work with light to make your photos even better. The photos on this page show how to take shots indoors in bright natural light. When there is little light, you have to use a flash.

● Taking photos in natural light is known as using **available light**.
● For a well-lit indoor portrait in natural light, place your subject near a window. This type of light is known as side light, and how harsh or soft it is depends on the type of daylight outside.
● Daylight often reflects off the walls of the room onto your subject, helping to lighten up shadowy areas. But this won't light the subject evenly. You can choose to concentrate on creating strong, side-lit effects, or you can use a homemade reflector (see right) for a more balanced effect.

◄ Here, side light from a window has lit one side of the girl's face very strongly and thrown the other side into shadow. The photographer positioned the girl so that some light reaches the side of the face away from the window. This gives a powerful, but natural effect.

◄ Holding a reflector close to the girl lights her face more evenly. Light from the window bounces off the reflector onto the subject. You can buy reflectors at photo shops, or you can make your own from a sheet of cardboard covered with kitchen foil.

▶ This natural, evenly lit picture is the result of using the reflector shown above. To take a photo as good as this, you need to spend time looking through the viewfinder and asking the person holding the reflector to change the angle until it is just right. Your subject might also need to move slightly.

CHECKLIST

✓ Move the subject towards or away from the window to control brightness and contrast.

✓ Tilt or turn the subject to control the amount of shadow.

✓ Take time to check your subject through the viewfinder.

✓ Use a tripod, if you have one, to keep the camera perfectly steady.

ACTION PICTURES

Many of your photos will involve action. Before you begin to take these pictures, you need to think about a few simple points.

● Whether you use a compact or an SLR, you'll need to understand how camera movement, composition, exposure and focus work together.
● Try to point the camera to the spot where the action will be before it happens.
● Use the right exposures and focus for the situation. Most compacts select these automatically—to set them yourself you need an SLR camera (see opposite page). But compacts still give you a variety of ways to take action shots, as the pictures on this page show.

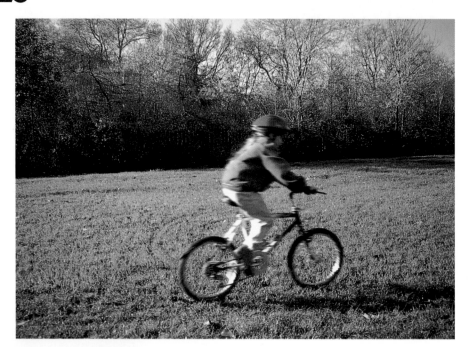

▲ For the simplest type of action photo, point the camera at the subject and press the button. A compact can't expose fast enough to freeze the movement, so the bicycle is blurred, but the trees are sharp, giving a feeling of action.

◀ With practice, you can take this sort of action shot. As the rider passes by, pan (move) your camera along with her, keeping her roughly in the middle of the viewfinder all the time. Press the button when you've got the background you want.

▶ In this photo, panning has been used again, but this time the photographer used the flash, even though there was plenty of bright light. This helps to freeze the movement and makes the bicycle stand out against the background.

TALBOT'S TIPS

Compacts are mostly automatic, so they guarantee good results, even with difficult action shots. But you have less control than with an SLR camera. Here are some tips on how to take action pictures with an SLR.

● Remember that different films have different speeds. For action shots in low light levels, choose a fast film.

● With an SLR, you can control the exposure yourself by selecting the shutter speed and the aperture. Short exposures help to freeze fast action. Long exposures provide the opportunity for amazing blurring effects. Being able to set the aperture yourself also means that you can control the depth of field.

● You can use a range of different lenses on an SLR. For example, wide-angle lenses include more of the scene in the picture and give greater depth of field. This helps with action pictures, because focusing quickly can be a problem.

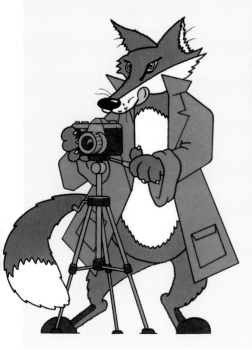

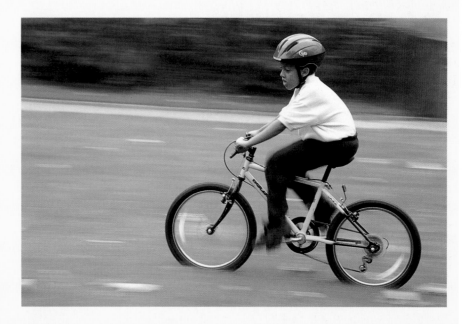

▲ By selecting the shutter speed and aperture, you can create exciting action shots like this. Notice how the background has blurred into streaks, giving a feeling of speed. The photographer took this shot while panning the camera. To avoid blur where you don't want it during slow exposures, hold the camera steady or use a tripod, if you have one. Fix the tripod so that it stops the camera from moving up and down, but still allows horizontal panning.

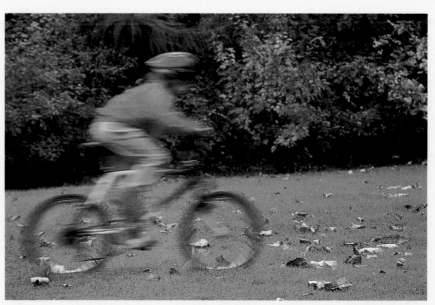

▲ Here, the photographer used the SLR's manual controls to take an unusual action shot of a ghostly bicycler. Being able to adjust the focus control exactly lets the leaves in the foreground appear in sharp detail. A slow shutter speed was chosen to create the eerie rider. At very slow shutter speeds, you may have a problem getting good results without a tripod.

AROUND TOWN

Everyday events, such as shopping, can make excellent subjects. But taking a good picture when you are in places such as crowded stores and streets can be tricky.

● In these kinds of places, you may not have enough space, or you may have too little light and too little time to compose the shot.

● If you have a zoom lens, use the widest angle setting in cramped conditions. Or zoom in through the crowd to pick out your subject.

● Switch on the flash for an evenly lit photo in awkward spots that have patchy light.

● If the scene is jammed with people, take a chance and set your camera controls to automatic, then hold the camera above your head and shoot.

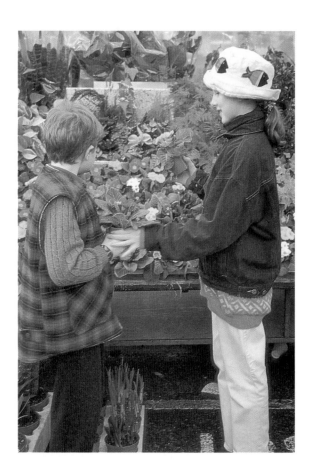

▶ In this market shot, the photographer got a clear view of her friends by standing on a nearby step and looking down at them. She used available light to create a soft, natural effect that looks more like a painting than a photograph. Look for scenes with splashes of bright color—like the flowers in this photo.

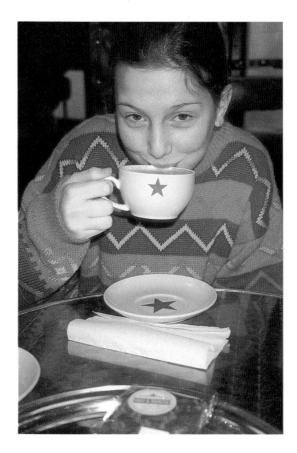

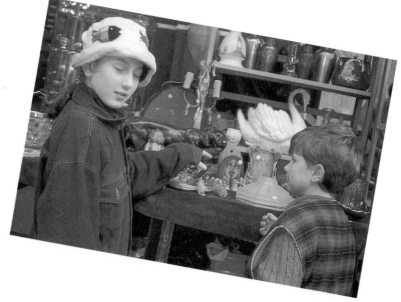

◀ This shot was taken in a cafe. The photographer avoided everyone else and concentrated on her friend drinking tea. She used a flash because there was very little light.

▲ This scene is crammed with detail. The photographer chose a low viewpoint, focusing on the antiques her friends were looking at. Don't take too long deciding on your shot. Because this was taken a second too late, the girl's eyes are shut.

Making a birthday tree

Daniel
July 14th
Loves: Football
Hates: Getting up early

Sally
November 28th
Loves: Music
Hates: Being bored

Nadine
February 9th
Loves: Ice cream
Hates: Spiders

Sean
April 6th
Loves: Swimming
Hates: Rain

Syrah
January 11th
Loves: Animals
Hates: Pink

I love:
Photography

ME
CARLY
May 3rd

I hate:
Cleaning

Craig
July 12th
Loves: Computers
Hates: Tomatoes

This idea is a variation on the traditional family tree. Use leftover photos to make a tree on any subject you like. The tree could show photos of the friends who went on a shopping trip or those who went to an amusement park, as show on pages 24 and 25.

1 Decide what tree to make and cut the right size piece of cardboard. It might be small, so that it fits into a folder, or large, to go on a wall.

2 Cut out a simple tree shape from green paper and carefully glue it to the cardboard, smoothing out air bubbles.

3 Choose your photos and cut them out. If you want oval shapes like the ones shown here, cut an oval shape out of cardboard and place it on each photo. Trace the shape so that you have a cutting guide. Move your photos around until you find an arrangement you like. Then, glue them down. Remember to leave enough room for the words.

4 Use a felt pen to draw the branches and leaves that connect the photos. Either write the text by hand or print it on a computer.

Telling a story

Regardless of what you're taking photos of, you'll want to be able to use your pictures to tell a story. Every day, newspapers and magazines use photographs to record events or to tell stories. You can do the same, but you can select any subject you like—we chose a day at an amusement park. You might want to let your photos speak for themselves, or you might add written captions.

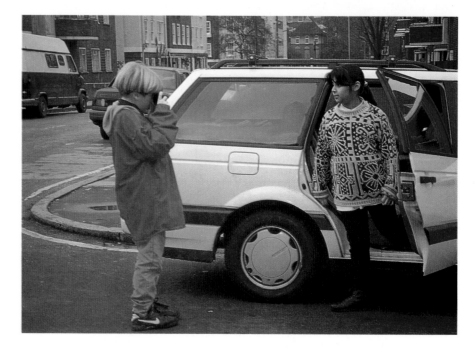

It's important to use your camera sensibly and naturally. With practice, you'll be able to take shots that tell a story well. A few basic rules will help.

● Use film that is the right speed for the conditions you expect to find. For taking photos in low levels of light or at night where you can't use a flash, choose fast film. If you're not sure what to expect, take a medium-speed film or a choice of films.

● You might want to consider using an SLR camera if you are telling a detailed story and you need total control over the settings. If you're feeling ambitious, you might even use different lenses for different subjects, if you have them.

● Once you understand the basic techniques, you need to think about your approach—what you want to show and the best way of showing it. For example, you'll want to use a different approach for a birthday party than for a sports event, or, in our example, a trip to an amusement park.

● Don't forget to take a photo that shows the start of your story—like the one above of people leaving for their vacation.

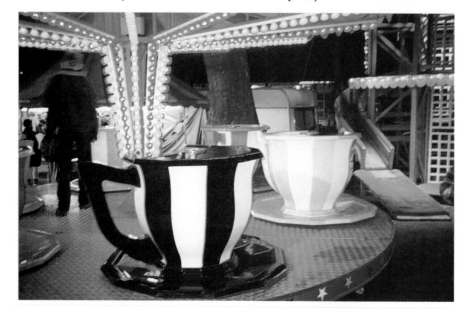

◀ This shot was taken by putting the camera on a ledge near a ride and using a long exposure. The automatic flash was off, so the lights on the ride lit up the scene. Including a person in the picture allows you to see how big the cups are.

▶ At this booth, people try to toss balls into the jugs. Most compact cameras focus on what's in the middle of the frame. Here, the photographer has made the prizes the center of the picture, so the emphasis is on the toys and the children are out of focus.

▼ The photographer was not sure when her friends would come out of the ghost ride, so she just pointed the camera and clicked.

▼ Be sure to include shots that capture the whole day. This photo was taken at the end of the day and shows who was there. The photographer prefocused her camera on the balloon to make it look sharp and sparkly. Then she moved the camera to include her friends and the interesting background. She didn't use a flash.

CHECKLIST

✔ Take along film that is the right speed for your location.

✔ You may want to take an SLR if you have one and know how to use it.

✔ Remember that you are the storyteller—take control of the situation.

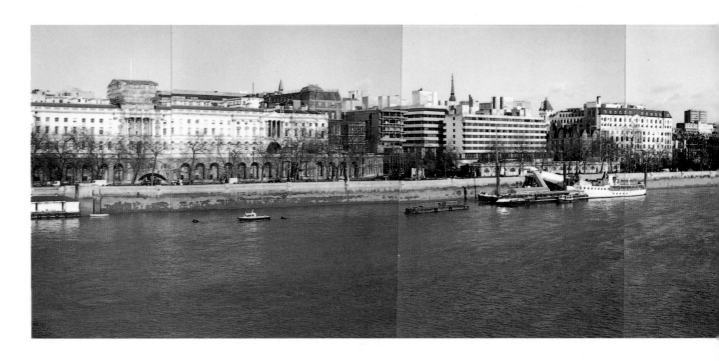

Making a panorama

Tell people about part of a special day or about a vacation with this spectacular presentation idea. A panorama is a long picture that shows a very wide view. You can make one from three or more photographs taken from the same viewpoint. To create your panorama, simply glue or tape the prints together.

CHECKLIST

✓ Find a comfortable, steady viewpoint.

✓ Look around and plan your panorama carefully.

✓ Make sure your pictures overlap by at least one third.

✓ Make sure you have enough film in your camera.

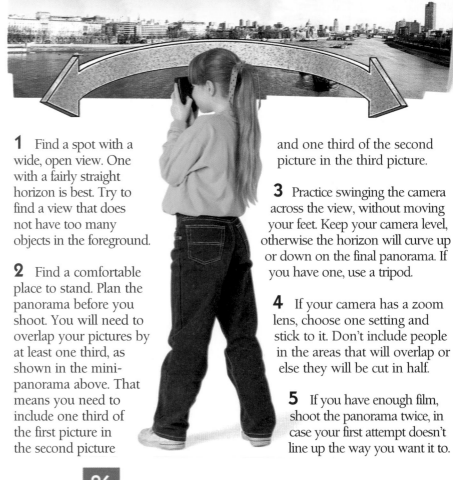

1 Find a spot with a wide, open view. One with a fairly straight horizon is best. Try to find a view that does not have too many objects in the foreground.

2 Find a comfortable place to stand. Plan the panorama before you shoot. You will need to overlap your pictures by at least one third, as shown in the mini-panorama above. That means you need to include one third of the first picture in the second picture and one third of the second picture in the third picture.

3 Practice swinging the camera across the view, without moving your feet. Keep your camera level, otherwise the horizon will curve up or down on the final panorama. If you have one, use a tripod.

4 If your camera has a zoom lens, choose one setting and stick to it. Don't include people in the areas that will overlap or else they will be cut in half.

5 If you have enough film, shoot the panorama twice, in case your first attempt doesn't line up the way you want it to.

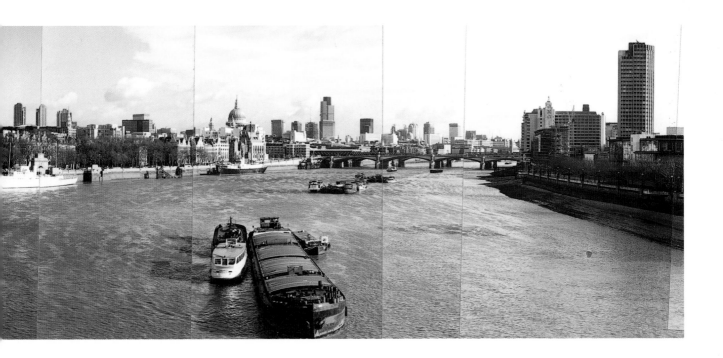

PUTTING YOUR PANORAMA TOGETHER

1 Spread the prints out on a flat surface and look at the way the overlaps work. Arrange the pictures carefully and make sure you are happy with their positions before you glue them together. Use small pieces of tape on the edges of the prints to hold them in place while you arrange them.

2 Once you have decided on your arrangement, glue the prints down one at a time, starting at one end.

3 When the glue dries, trim the edges of the panorama to a neat rectangle (or cut out a more creative shape, if you are feeling adventurous).

TALBOT'S TIPS

● Make a trick panorama with the same person in every shot. Let your model move across the panorama so that he or she appears in each shot. Keep your model away from the areas that overlap.

● To make a circular panorama, take shots as you move around in a complete circle. Glue the ends of your prints down so that they join to form a circle.

● Create unusual panoramas from shots of the same view taken on different days or with different models or objects in them.

● Use vertical photos to fit in more of the foreground. You can also get more foreground in your panorama if you take two series of shots, one above the other. You will need to overlap these vertically as well as horizontally.

Vacations

The success of a vacation depends as much on your camera as it does on the weather. Use your pictures to show your friends where you went on your vacation and how much fun you had. Your photos are a permanent record. Although you may use your video camera when you are away, photographs can provide a record that is just as exciting and vivid as a video.

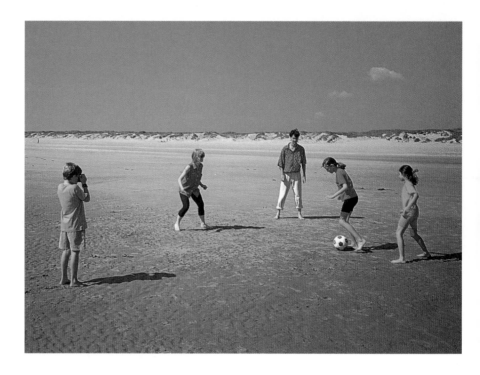

ON THE BEACH

The beach is a popular place for vacations. Beaches create their own special conditions, so keep the following points in mind.

● Try not to move your camera too much. Be careful near water, sand or grit. Salt water is especially damaging if it gets inside a camera. Don't get water on your lens or your shots will be fuzzy. Keep your camera in a protective cloth bag, out of the sun.
● A beach is the perfect place for all kinds of subjects. On a sunny day, you can create striking shots with wide views of sand, sea and sky. You'll want to take closer shots of people, umbrellas and beachballs, with clear, bright color and detail. In misty weather, you can take moody, mysterious pictures.
● Don't point your camera towards the sun or you'll overexpose the film. However, when you aim towards strong light, you can create dramatic figures.

The photos on this page have figures that appear as solid black shapes. In the shot above, the photographer has bright light behind him. Positioning yourself with the sun behind you reduces the risk of overexposure but it means that you may get your own shadow in the picture.

◀ The strong images of the children in this photo were created by shooting into bright light.

▶ This shot was also taken in bright light, but we can see more detail in the figures because the photographer used a flash.

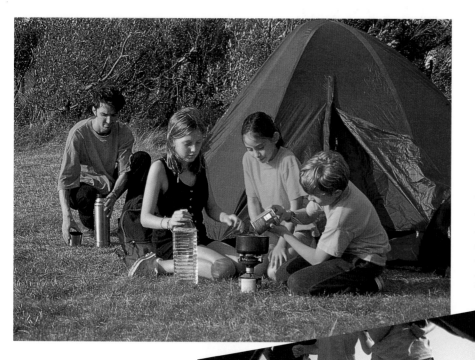

CAMPING

Campsites provide plenty of subjects for exciting photography.

● The same rules of camera care that apply to beaches apply to camping. Cameras are often damaged by rain and damp weather. Very hot or very cold conditions can harm your camera and ruin your film. If you leave a camera in the sun, the case may warp or bend. The colors in your pictures might be affected, if your film is exposed to heat.

● The day-to-day activities of camping, such as cooking and washing mess kits, give you all sorts of interesting possibilities for taking photos. You can also use the shape of the tent as the subject of great compositions.

▲ Strong light helped make this a well-exposed, brightly colored picture. Compacts are designed to balance highlights (brightest areas), midtones and shadows and to produce the correct exposure.

▶ This shot, taken from inside the tent, created an unusual composition. Using parts of figures in shadow creates interesting shapes.

CHECKLIST

✔ Don't let your camera get wet. Keep it away from water, grit and sand.

✔ Don't leave your camera or film in the sun. Never let them get too cold either.

✔ Remember, you can take great shots in all kinds of weather.

TALBOT'S TIPS

● Take several speeds of film along on your vacation so that you can shoot all kinds of subjects. Take slower speeds for close-up shots, medium speeds for a range of shots in daylight and fast speeds for action shots and poor lighting conditions. Remember that if you have a compact, it may flash automatically in low light.

● If you have an SLR and different lenses, you may want to take these along so that you can try out

different effects. For example, with a telephoto lens, you can take close-ups of a subject while standing away from the subject.

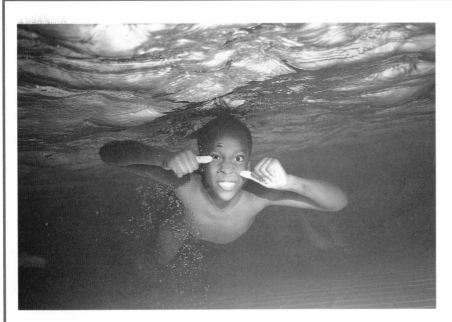

◀ This photo was taken with a disposable underwater camera. Except that the air bubbles tell you he is swimming in water, you might believe that the boy was a giant floating under a white cloud. It's difficult to know whether the mysterious light above the boy is coming from above the pool or from the flash.

UNDER THE WATER

You may want to see the effects you can get by taking pictures of people or objects that are in or under water. As explained on pages 28-29, you have to be careful when you take a camera near water, but there are special waterproof cameras that can take underwater shots. Remember that you need to be a very confident swimmer before taking underwater photos. You must also be sure there is an adult nearby.

Until recently, underwater photography was impossible unless you were a professional marine photographer using special equipment. Today, lightweight underwater cameras are much easier to handle, but they are still expensive. However, you can buy disposable underwater cameras that are perfect for using on your vacation.

● Taking photos of people in shallow water can create interesting effects because light travels differently through water than it does through air. For example, when people stand in water, their bodies seem to bend at the water line.

● Colors in and around water may be strange because, as we said, light behaves differently underwater than it does in air.

● If you visit a marine center or take a trip in a glass-bottom boat, see what effects you get by shooting through glass.

CHECKLIST

✓ Check that it's safe to take photos in or under water.

✓ Make sure that an adult is present.

✓ You can get great shots and have lots of fun with disposable cameras, but don't expect to take perfect photos.

✓ Remember that colors will be distorted in and around water.

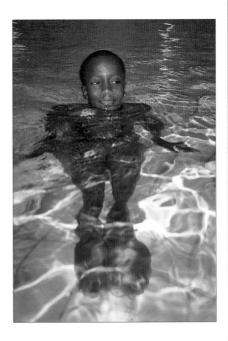

▲ This shot from an ordinary camera was taken at a swimming pool. The photographer was looking into the water at the boy, who was sitting on the bottom of the shallow pool. The water distorted the boy's body in all kinds of ways—look at how enormous his feet are! You can use the distorting effects of water to take all kinds of funny photographs of people and objects.

CLOSE-UPS

Close-up photography opens up another fascinating world—and it's easy to get great results.

● Beaches, campsites and hotels offer endless possibilities for close-up work. Whether it's sunny or raining, you can always find something worth shooting. On the beach, try looking into little pools of water left at low tide or take shots of shells, pebbles and seaweed. If the weather is bad, try taking close-up pictures of tickets, maps or stamps that say something about your vacation.

● Close-up photography works best with slow film, which picks up fine detail.

● You can take fairly good close-up shots with most cameras, but ordinary lenses can't focus properly

if you get too close to your subject. Many new cameras have a close-up lens built into them, so you can zoom in on subjects. These cameras often include a macro lens, a special lens for very close shots. You can buy macro lenses for SLRs.

● Remember that close-up photographs need good light to capture all the detail properly.

● Until you get used to taking close-ups, you may have to take a few shots to frame your subject just the way you want it. You need to adjust the way you frame your picture because, with a compact, you look through a viewfinder—not through the lens that takes the picture, as with an SLR.

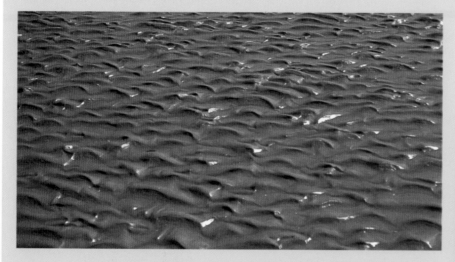

▲ This photo shows wet sand with sparkling, sunny highlights. The shot wouldn't work from a distance. Zooming in close to the sand created a mysterious picture. You might not even recognize this as a picture of sand.

▶ Seaweed and shells also look very different close up. Try arranging shells and pieces of seaweed. Then, draw your fingertips across the sand, adding faint patterns. Here, the light has created highlights and shadows that produce an interesting effect.

Creating a vacation collage

Once you begin to use your camera, you'll probably have plenty of extra prints that you don't want to give away or save for yourself. Using these extra photographs to make a collage (montage) is a great way to create special images that say much more than a single photo can.

▶ To make your collage, begin by experimenting with different arrangements of the prints.

● You can see collages in some magazines. Look at these to find ideas. You will see that many collages mix pictures with words—try adding words or letters cut out of newspapers or magazines to your collage.

TALBOT'S TIPS

● You can add lots of other things to your collage. For example, if you are making a collage about a trip to a museum, you could include your entrance ticket and part of a leaflet from the museum along with shots of your friends and the building. Or you could take close-up shots of items such as tickets and signs and include these.

● Perhaps one collage isn't enough. You might want to tell a story by creating a series of collages, each one dealing with a different part of a trip or event.

1 Lay the prints out in the pattern that looks best. Think about how much space you want to leave between them and how much you want them to overlap.

2 Put a piece of tracing paper over your design and trace very lightly around some of the key shapes. Don't press on the prints. This tracing will give you a guide if your collage gets bumped out of shape.

3 Cut your shapes out with a pair of scissors, coat the back of them with glue, and stick them to a piece of cardboard. Be careful not to get glue on the front of the prints.

4 After you have glued each shape in place, lightly smooth the shapes to remove any air bubbles.

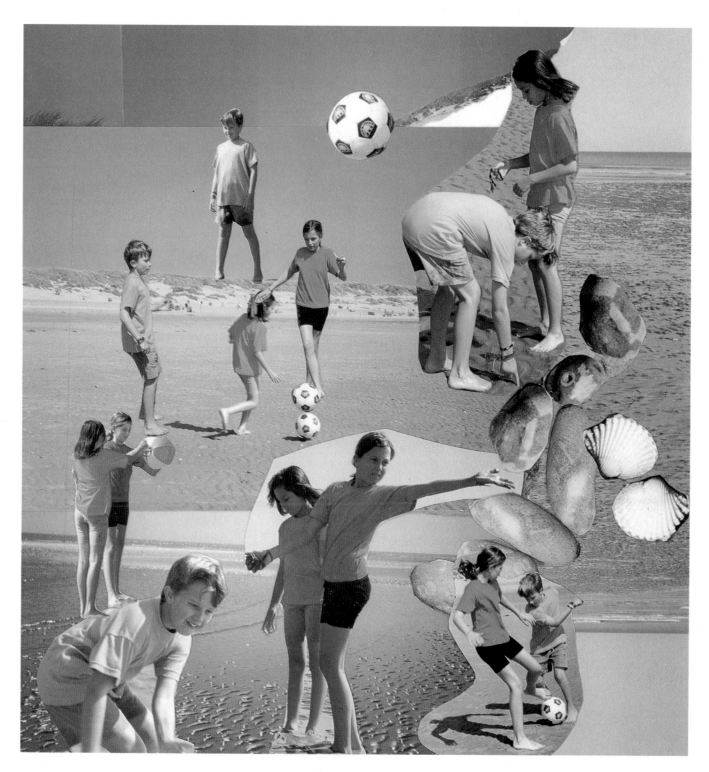

Here are some ideas to make your collage more interesting. Use your imagination to create others.

● Instead of carefully cutting your shapes out with a pair of scissors, try tearing them. This produces a different effect that can be very interesting for certain types of subject.

● Carefully rub fine sandpaper over the back of your cut-out shapes to make the edges thin. This way, the place where they come together will be less obvious. This will also make the collage appear more like a single picture instead of a collection of separate parts.

● When you finish the collage, you can change some parts of it by adding new details to the photos with pencils, crayons, felt pens or paints.
● Take a photo or make a color photocopy of your collage, put it on a sheet of paper and write something about it.

Fun with a flash

Modern compact cameras have a built-in flash so that you can take photographs at night or when the natural light is dim. Your flash is perfect for taking photos of special moments at birthday parties or family get-togethers. You can also use it when you want to take shots on dark nights. Be creative and enjoy using your flash.

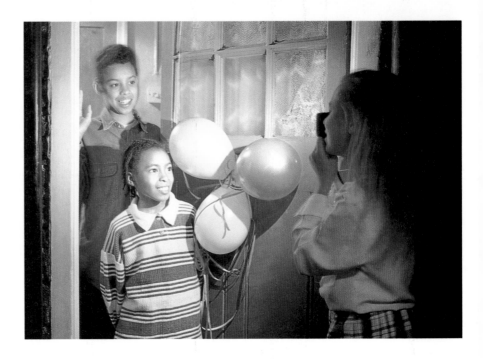

Because a built-in flash is always available for use, you don't have to carry any other equipment around with you.

The automatic flash on compacts has a special measuring system. It checks whether you need the flash to light the scene properly and sets the correct exposure for a flash shot.

● In the photograph at the top of the page, the photographer is using a flash to take a picture of friends. When using a flash, try not to stand too close to your subject. If you're too close, your shots will have very hard shadows and overexposed light areas, and you'll lose a lot of detail.

● Don't forget that you can use your flash in daylight to give you extra detail in shadowy areas or to produce more light when you need it.
● Be creative. For example, try taking pictures of street scenes or animals at night (always have an adult with you).

◄ This photo shows party guests outside the house in the evening. It wouldn't have come out without using a flash. The camera adjusted the correct exposure for the white shirts, but there isn't quite enough light to show the detail in the dark background. This produced a shot full of dramatic contrast.

LIGHTING A SCENE

The automatic flash unit on a compact will usually give you good results, but it is not ideal for all situations. Make the most of your compact flash by learning when it is most effective.

● A compact flash only travels a limited distance, so it is not useful for shots of large scenes. Instead, move in closer and pick out a smaller area.

● Make sure you don't accidentally block the flash unit as you take your picture.

● If your subjects are close to the camera, try to avoid **red eye**. When this happens, people's eyes look bright red because the low light level makes the eyes open up more, and the flash lights up blood vessels inside them.

Your camera may have a special "red eye" control to prevent this. If it hasn't, simply ask people not to look straight at the camera.

▶ You can see that this picture didn't have enough light. The compact flash unit wasn't powerful enough to light the scene evenly. The best compact flash photos are taken close to the subject, but not too close, because that would make the flash too direct and hard.

▲ The same photographer also took this more successful shot with a compact flash. It's a better picture because the photographer moved closer, picking out a smaller group. It's also more interesting than many wider shots in which the viewer is not sure what to look at.

CHECKLIST

✓ Avoid close-up flash photography because it produces too much contrast.

✓ Make sure that your subject isn't too far away to be lit properly.

✓ Try using a flash to give extra light in daylight for outdoor or indoor shots.

✓ Avoid red eye by using special controls on your camera or by making sure people don't look straight into the camera.

TALBOT'S TIPS

With an SLR, you can create all kinds of flash effects, but the equipment is not as easy to use or as portable as a compact with an automatic flash.

The flash unit fits on the top of an SLR camera. Once you have set the controls, you can simply point and shoot, or you can try one of the following options.

● You can attach the flash unit to the camera with a long cable. This lets you position the flash where you want it.

● For a soft, evenly lit effect without red eye, bounce the light from the flash off the ceiling by tilting the flash unit up. You can also try bouncing the flash off a wall. The ceiling or wall needs to be light in color for this to work properly.

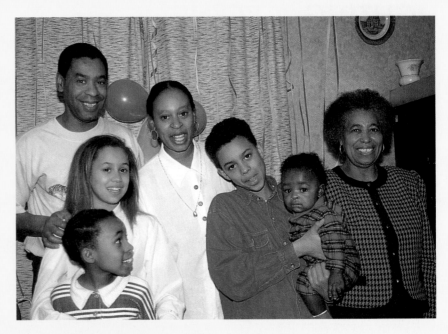

▲ This shot was taken with a flash unit mounted on the top of an SLR camera. The picture is well exposed, and a large area is evenly lit. The light created by the flash is very harsh, and the people's faces are shiny because the flash went off right in front of them.

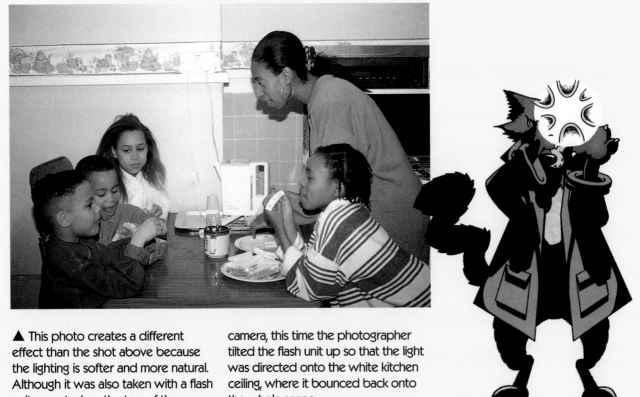

▲ This photo creates a different effect than the shot above because the lighting is softer and more natural. Although it was also taken with a flash unit mounted on the top of the camera, this time the photographer tilted the flash unit up so that the light was directed onto the white kitchen ceiling, where it bounced back onto the whole scene.

SPECIAL EFFECTS

You can use SLR flash units to create all kinds of unusual shots.

● Experiment with multiple images like the one on the right. To do this, set the shutter to a very slow speed, press the shutter button and set off the flash several times while the shutter is open.

● Experiment with a moving subject. Try snapping a friend dancing, and you will see different stages of movement in one photo. In the picture on the right, the photographer created movement by zooming the lens in and out as she took the photo.

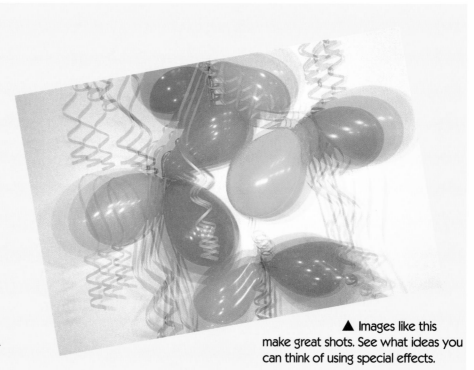

▲ Images like this make great shots. See what ideas you can think of using special effects.

Greeting cards

Here is another way of using your prints—make greeting cards for your family and friends. Think about your final design before you glue anything down.

1 Think about your design. What shape and size should the card be? Do you want to add things from magazines or newspapers, or do you want to draw some features in yourself? Why not add captions?

2 Cut and fold stiff paper to form the greeting card.

3 Cut out people or objects from your prints and, if you want, from magazines or newspapers. Arrange them on the card until you are satisfied. Then glue them to the paper.

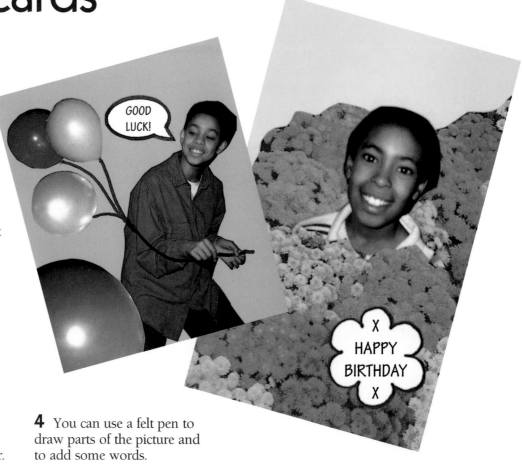

4 You can use a felt pen to draw parts of the picture and to add some words.

Pets and animals

Pets and animals are popular subjects, but animals aren't always easy to photograph. They behave in independent ways and rarely stay still when you want them to. You'll find it a challenge to take animal pictures, but it is rewarding to capture the personality of a pet, whether the animal is yours or a friend's.

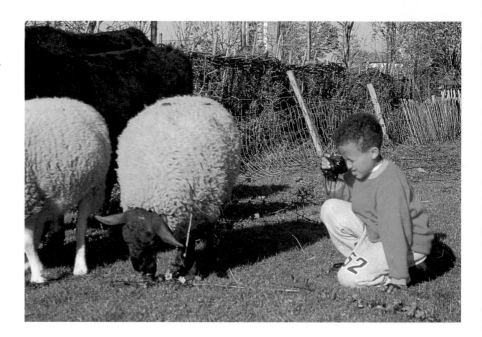

You need a special approach to work with animals. You may sometimes need a bit of practice before you feel really confident about taking photos of them. Here are some important things to keep in mind.

● If you are taking pictures of someone else's pet, try to get to

know the animal over a period of time. This way, you'll understand the animal, and you can think about composition and lighting without worrying that it might do something unexpected at any time. The animal will also behave more naturally if it knows you because it will feel more relaxed.

● Watch all kinds of animals until you get to know how they communicate with each other.
● Always try to take natural shots of animals. Lively action photos are much more exciting than a posed picture of a pet.
● Never try to pose a picture so that it makes an animal uncomfortable.

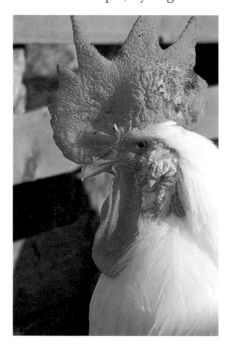

◀ This photo of a rooster was taken with a compact camera using a macro zoom lens. It is an excellent example of good exposure in bright sunshine. In this picture, all the details of the white feathers are sharp and vivid. If you are using an SLR camera, remember you need longer exposures for good close-up work.

CHECKLIST

✓ Remember that it helps if you understand animals and how they behave.

✓ Aim for natural shots, not posed ones.

✓ Be sensitive in the way you treat animals.

✓ Don't get too close, unless you know the animals well.

✓ Good shots need to show both detail and movement.

● Don't get too close to animals, especially those you don't know. Don't frighten them with sudden close-ups or flash exposures. Your pictures will be much more effective if they show that you have a sensitive attitude towards animals.

● Think about whether your animal photos would be more effective if you used black and white film.

● If you can, use techniques to freeze fast movement. To take a close-up, you will need more depth of field to give you vivid detail. If you have an SLR, set your camera for a very small aperture to help you produce good detail.

▶ This photo freezes the dog's motion in a lively, dramatic position. The way in which the ball enters the frame of the picture creates a strong design. This is a good example of a picture that would also work well as a black and white shot.

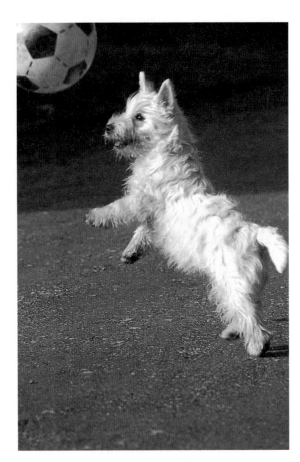

◀ If you are photographing people with animals, position your subjects so that one is not hiding the other. They should look as though they are connected to each other. The best results come when you are patient and wait for your opportunity.

▶ These geese form a stunning composition. Geese have an interesting shape, and a line of them creates a pattern. There is also something funny about this image, which makes it very appealing.

With a little help...

With a modern compact camera, you can take good photographs in almost every situation. But you can also buy special equipment, such as camera clamps and minitripods, that will help you achieve even better results. You can also create a wide variety of exciting special effects by using bits and pieces of things found around your home.

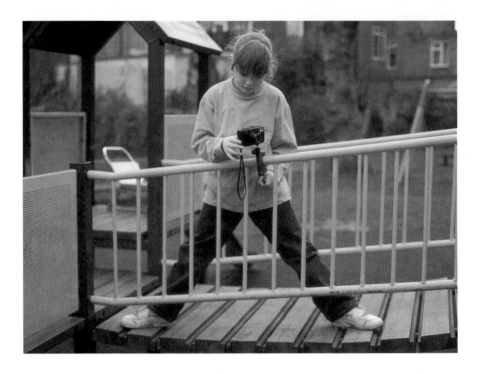

With practice and some good ideas, you should be able to take great pictures on the most basic cameras, without extra equipment. But you may want to explore your hobby, or you may find that you frequently take pictures in difficult situations. You don't have to spend a lot of money on complicated equipment. On this page, you can see a couple of the inexpensive gadgets that you can find in any good photographic shop. On the opposite page are some suggestions for **filters** that you can make yourself. Can you think of other homemade equipment you could create?

GADGETS

● You can buy small clamps that you screw into your camera and attach to a support, such as a door frame, table leg or railing, as shown at the top of the page. These clamps help you take pictures in situations where you might find it difficult to hold your camera steady. Make sure you can still see through the viewfinder. Clamps are also useful for self-portraits, if your camera has a self-timer.

● You can buy minitripods to use for the same reason. You can fold them up and carry them in your pocket. Obviously, they fit into smaller spaces than ordinary tripods.

▲ Minitripods screw into the base of your camera, just like the full-size ones. They are very light and specially designed to be used with a compact camera—they could not take the weight of an SLR.

CHECKLIST

✓ Camera clamps allow you to place your camera in unusual, tight spots, but make sure that you can still see through the viewfinder.

✓ For polarized pictures, use clean sunglasses and make sure they almost touch the front of the lens.

✓ With an SLR, look through the viewfinder while you turn the sunglasses around to get the result you want.

COLOR FILTERS

You can put filters in front of the lens of a camera to change a photo. They can improve or alter the colors, either subtly or very dramatically. They can also create special effects. Professionals use filters made of glass, plastic or a clear, shiny material called acetate.

You can make your own filters from sheets of colored acetate sold in art supplies shops. Simply cut out squares of acetate and tape them over the lens. You can create the same effect with any clear, colored plastic. Try taping two colors over different parts of the camera lens to color different areas of the picture.

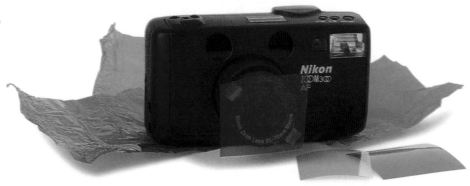

▲ Homemade filters are simple to make. Here, a square of acetate has been taped over the lens of the camera. You can use double-sided tape to attach acetate.

▲ This moody red sky is very dark because the filter used here was twisted slightly to make it denser.

◄ This shot was taken with a lilac and a green acetate filter placed next to each other. The joint between the filters is invisible because the lens can't focus on anything that close to it.

POLARIZING FILTERS

Many professionals use **polarizing filters**. These reduce the glare reflected back from shiny surfaces (such as the sea) in strong light, and they make colors richer. Polarizing sunglasses also cut out glare. You can use them as a homemade filter by putting them in front of the lens of your camera. First, make sure that they are clean. Polarizing lenses and glasses are set at a special angle so that they cut out many of the light rays reflected off shiny surfaces.

▶ To use polarizing sunglasses as a filter, ask a friend to hold them over the camera lens while you shoot. If you have an SLR camera, look through the viewfinder and turn the glasses around until they cut out all the reflections you don't want.

Creating a set

You'll enjoy finding unusual ways to use your photography—as you'll discover if you try the project shown on these two pages. For this one, all you have to do is make a simple model or set and take photographs of it. These shots turn it into something really special. If you don't want to make a whole set, you can just shoot a small group of objects. You can choose any subject—use your imagination!

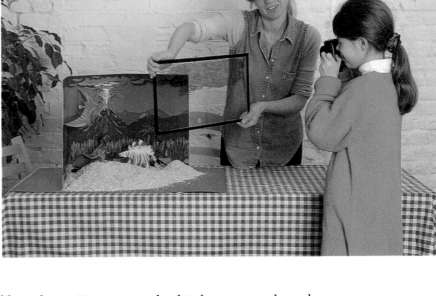

You can use your camera to create a world filled with all kinds of illusions. For example, you can make things look larger or smaller, closer or farther away, even lighter or darker than they really are.

Depending on what else you choose to include in your shot, you can make a pebble look like a mountain or a pile of sand look like a desert. You can use this kind of shot for a variety of projects. You can see from the photo above that a great set can also be very simple.

For this set, the background and dinosaurs were made of painted cardboard. A pile of gravel in the foreground completes the scene. Here are a few points to remember when you create your own set.

● Make sure that nothing is wobbly enough to fall over at a crucial point.
● When you are ready to start shooting, ask someone to help you—holding filters, reflectors or any other special equipment.

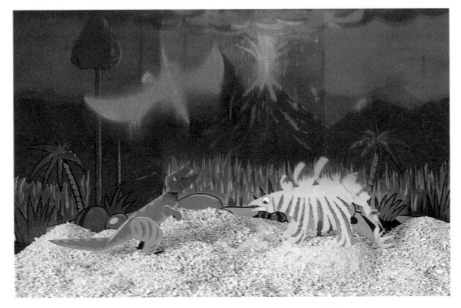

◀ This shot uses a mixture of simple photographic effects. If you look at the shadows, you'll see that the photographer lit the set with bright light from the left. A red cloud spreads across the sky. The photographer created this effect by taking the photo through a piece of plastic that had red felt pen marks (see top of page). If you have a compact, you should prefocus on the set, not on the cloud, which should be out of focus.

▶ Experiment with focusing on different parts of your set to create all kinds of effects. To take a shot like this one, focus on the foreground of the set. This emphasis on the foreground makes the dinosaurs stand out in a dramatic way and creates an image similar to an early Hollywood film set.

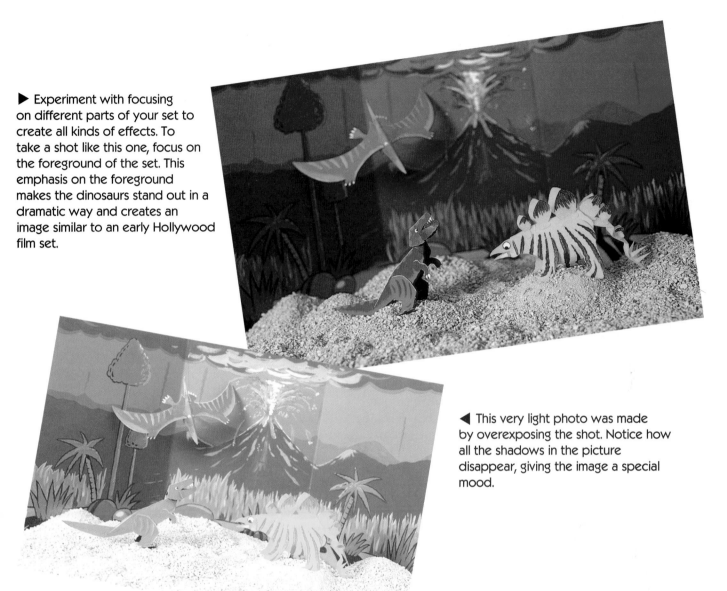

◀ This very light photo was made by overexposing the shot. Notice how all the shadows in the picture disappear, giving the image a special mood.

▶ More complicated lighting effects can produce dramatic shadows. This is an ambitious shot. You'll need extra equipment and some help. Fit a detachable flash unit to a tripod to the right of the set (or ask someone to hold it), and switch it on. When the flash on your camera goes off, it will set off the other flash.

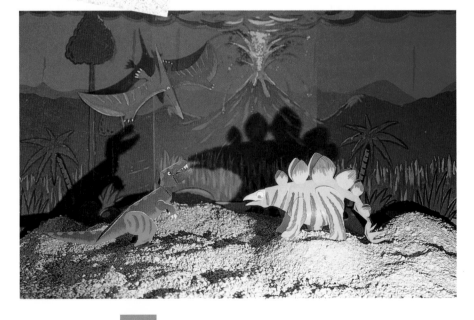

Glossary

Aperture
A kind of hole inside the camera. It works with the **lens** to **focus** light on the **film**. The aperture is like the iris in an eye, opening to let in more light in low light, and closing in bright light. On some cameras, aperture size is measured in **f-stops**. A large number, such as f-16, is a small aperture, and a small number, such as f-2.4, is a wide one. The larger the aperture, the smaller the **depth of field**.

ASA
See **ISO**

Autofocus
A system that **focuses** the image automatically. An invisible beam of infrared light bounces off the subject and comes back to the camera. As it does, it measures how far away the

subject is. A motor then adjusts the **lens** to bring the subject into **focus**.

Automatic
A fully automatic camera makes all the adjustments so that you don't have to set any controls yourself. Most compact cameras are automatic, although some also allow you to set various controls yourself.

Available light
This is the term used to describe the amount of natural light available in a situation. Available light photography involves taking pictures in natural light in situations where you might need to use a **flash**.

Cable release
This is a flexible cable that screws into the **shutter** release button on **SLR** cameras. Pressing a button on the end of the cable lets you take a photograph without holding the camera. This is useful if you want to avoid **camera shake**. A long cable release is ideal for **self-portraits**.

Camera shake
This happens with long **exposures**, when it is not possible to hold the camera still during the exposure. Pictures with camera shake look blurred, or, if they are in **focus**, the image is repeated in steps across the photograph.

Depth of field
This is the area in front of and behind your subject that is also in focus. A small **aperture** gives you a greater depth of field, and a large aperture a smaller depth of field. **Wide-angle lenses** give you a greater depth of field.

DX coding
This is a pattern of silver-colored metallic squares on the **film** cassette. The coding tells some cameras what speed the film is. Not all cameras can read the codes, so you might have to set the film speed yourself.

Exposure
The term given to the amount of light that falls on the **film** when the **shutter** is open. Both **aperture** and shutter speed control the exposure: how wide open the aperture is and how long the shutter stays open. Many cameras automatically control the exposure. If you have manual controls on your camera, you can vary aperture and shutter speed in relation to each other so that the same amount of light reaches the film. For example, an aperture with an **f-stop** of f-16, combined with a shutter speed of $^1/_{30}$ second is the same as f-11 at $^1/_{60}$ second or f-22 at $^1/_{15}$ second.

F-stop
The size of the **aperture** is measured in f-stops. The higher the f-stop number, the smaller the size of the aperture. On many cameras, the f-stops are marked around the outside of the **lens**.

Fill flash
Fill flash can light up dark or shadowy areas of your subject in situations where you might not usually use a flash. When there is very little light it can brighten up the subject. In bright light, where the light is coming from behind your subject and creating a silhouette, you can use a flash to light up some of the detail in the silhouette.

Film

Film—black and white, color **negative** or color transparency (**slide** film)—is made of flexible plastic. Film has a coating containing a silver substance and is very sensitive to light. When you **expose** film to light, the silver coating reacts and forms an image on the film. When the film is developed, a solid image is formed. With color film, special dyes form at certain stages in the process, producing the final full-color images.

Film speed

The speed of a **film** shows how quickly it reacts to light. Films are made with different speeds, to cope with different lighting conditions. The speed is measured in ASA (or ISO or DIN) numbers, marked on the film cassette. Slow films (ASA 25 to ASA 160) are suitable for normal daylight. Fast films are used mainly in lower light. They are also useful for fast-moving objects, when you need the shortest **exposure** time possible so that the moving image does not blur. Fast film speeds range from ASA 400 to ASA 3200. The faster ones produce grainy pictures.

Filter

This is a circular or square-shaped piece of plastic or glass that fits over the camera **lens**. It is tinted so that it changes the quality or color of the light that reaches the **film**. You can use certain kinds of filters to cut down glare from very bright objects. Other types create special effects.

Fish-eye lens

A fish-eye **lens** has a very wide angle of view—180 degrees. It takes photographs that are circular. The subject is very distorted, and objects lean inward.

Flash

A sudden flash of very bright light used to give extra light in dim conditions. You can also use a flash to freeze movement. If you have manual controls on your camera, any **exposure** faster than about $^{1}/_{250}$ second should freeze most movement. Flash units are built into many compact cameras. They can be attached to **SLR**s. On some compacts, the flash fires automatically when light levels are low. On others, you can choose to turn the flash on manually at any time, even when the light level is high enough not to require flash.

Focal length

This is the light-bending power of a lens. Different lenses have different focal lengths, and each one bends light rays in a different way in order to focus a subject. Depending on the focal length, lenses make objects seem farther away or closer to the camera than they really are, or they give an impression of normal distance. A **standard lens** has a focal length of 50 mm. A lens with a shorter focal length is known as a **wide-angle lens**. It gives a wider angle of view than a standard lens. A **telephoto lens** gives a narrower view than a standard lens.

Focusing

This is the way in which the **lens** system in a camera moves backwards or forward in order to make the image look sharp. Usually, you try to take a sharp picture of the part of the image that is most important, because usually you can't focus on the whole scene. Most compacts use **autofocus**, which means that the focusing is adjusted automatically. **SLR** cameras usually use **free focus**. You have to manually adjust the lens as you look through it to bring an area into focus. Using a wider angle lens and a small **aperture** brings more of the image into focus.

Fogging

If your pictures are very soft, grey or muddy and look flat and dull, then the **film** has probably been fogged. This happens when you **expose** your film to light by mistake, for example, when you open the back of the camera halfway through a roll of film. When you fog the film, you can ruin the whole roll.

Fox Talbot

William Henry Fox Talbot was an Englishman who was an early pioneer of photography. In his early photographic experiments during the 1830s, he made photograms. In these, he pressed objects, such as leaves and lace, against glass plates coated with a light-sensitive substance. He lived at Lacock Abbey in Wiltshire, England, which is now a center for photographic history.

Framing
This is the term used to describe what you choose to include in your picture and how you compose it. The two basic framing formats are **portrait**, which is vertical, and **landscape**, which is horizontal.

Free focus
This is the method of focusing used by **SLR** cameras. You **focus** an image manually by rotating part of the **lens**.

Infrared light
See **Autofocus**

ISO
When you look for the **film speed** on your film cassette, it will probably have the letters ISO in front of it. These letters stand for International Standards Organization. Other letters that are also used are ASA, which stands for American Standards Association and DIN, which stands for Deutsche (German) Industrie Norm.

Landscape format
This is a horizontal picture produced by holding your camera in the usual position.

LED
These letters stand for light-emitting diode. On some cameras, display panels and separate flash units use LEDs to provide information, such as the number of pictures you have taken.

Lens
A curved disk made of plastic or glass. The lens bends light rays from the subject as they enter the camera and **focuses** them so that they form an image on the **film**.

Light meter
A light meter records the amount of light reflected from a subject so that you can set the correct **exposure.** Most cameras have a built-in light meter, although professionals use separate, hand-held ones so that they can set an exposure precisely.

Light spectrum
Ordinary light is made up of rays of different wavelengths, each of which has a different color. The light spectrum ranges from violet to red. You can see this series of colored bands in a rainbow.

Macro lens
This type of **lens** allows close-up (but not microscopic) photography. You can buy separate macro lenses for **SLR**s. Some compacts have a **zoom lens**, which is like having several lenses in one, including a macro lens.

Negative
A photographic image on **film,** from which **prints** are made. On a negative, areas that were dark in the original scene appear transparent, and those that were light appear dark. When you process the negative film, this is reversed, and a **positive** print is produced.

Panorama
Some camera **lenses** can photograph a very wide view, called a panorama. This is a much wider view than even normal **wide-angle lenses** can produce. You can now buy disposable panoramic cameras. You can also create your own panorama by taking a series of photos of different sections of a scene and gluing them together.

Polarizing filter
Light usually travels in all directions. Polarizing **filters** only let light pass through in one general direction. You put them over lenses to cut out unwanted light, such as the very bright rays reflected off shiny surfaces.

Portrait format
This is a vertical photograph taken with the camera turned on its side.

Positive image
This is the opposite of a **negative** image. Positive **film**, also called transparency film or **slide** film, behaves in a different way than negative film does and is often used to make slides.

Print
A flat photographic image on paper, usually made from a **negative**.

Red eye

When people are staring straight at the camera and the **flash** goes off, their eyes often appear bright red in the photo. The flash lights up red blood vessels behind the pupil (the dark spot in the middle of the eye). You can avoid red eye by bouncing the flash off another surface so that it is not reflected directly back from your subject's face and by asking him or her not to look straight at the camera. Turning on the lights will also help. Some cameras have a device that cuts down on red eye. This works by firing off a series of small flashes before the main flash goes off. The bright flashes make the pupils contract.

Self-portrait

A self-portrait is a picture of yourself. This is easy to do when your camera has a **self-timer shutter** switch.

Self-timer

A self-timer delays the opening and closing of the **shutter** for several seconds after you have pressed the shutter release button. This gives you time to rush around to the front of the camera and position yourself for a **self-portrait**.

Shutter

A kind of door behind the **lens**. When you press the button to take a picture, the shutter opens to let light into the camera. How long it stays open affects the **exposure**—the amount of light reaching the **film**. In some cameras, the shutter and **aperture** are combined.

Single lens reflex camera (SLR)

These cameras were developed in the 1960s. With an SLR, you look at the photograph you plan to take through the **lens** used to take the picture. Light from the subject travels through the lens and then hits a mirror inside the camera. The light rays bounce off the mirror and travel through a prism before they reach the **viewfinder**. The prism turns the image the right way up for viewing. The moment you push the **shutter** button, the mirror lifts up, so that light reaches the **film**. You can buy different lenses to fit an SLR.

Slide

A slide is made by putting a piece of **positive film** into a cardboard or plastic frame called a mount.

Standard lens

A standard **lens** usually has a **focal length** of 50 mm. Photos taken with a standard lens seems as if they were taken at a normal distance. Although a standard lens makes things appear the same size as we see them, our eyes give us a wider view.

Telephoto lens

A telephoto **lens** has a long **focal length**. It acts like a telescope, making objects appear closer to the camera than they really are.

Time release

See **Self-timer**

Tripod

A device with three legs for holding a camera. You can adjust standard tripods to different heights, and you can then tilt the camera or move it across the scene in front of you. Tripods are useful when you want to avoid **camera shake**.

Viewfinder

The window through which you see the scene to be photographed.

With an **SLR** camera, the scene you see through the viewfinder is exactly the same as the one the **lens** sees. This means that what you see is exactly what you will take in your photo. The viewfinder of a compact shows a slightly different scene from the one the lens sees.

Wide-angle lens

This **lens** has a much wider angle of view than a **standard lens**. It fits a much wider scene into the picture than a standard lens. Wide-angle lenses also have a greater **depth of field** than standard lenses.

Zoom lens

This type of **lens** is like several different lenses in one. By changing the setting, you can take **standard**, **telephoto** or **wide-angle** shots. Some zoom lenses can be used to take **macro** pictures.

Index